Cape May for All Seasons

Mary T. McCarthy

Photography by Harriet Wise

Foreword by Tom Carroll
Afterword by Bruce Minnix

Miele—
write on!
Mary McCarthy
2013

PRESERVATION
M E D I A

Copyright © 1999 by Preservation Media

Library of Congress Catalog Card Number: 98-96789
ISBN 0-9668335-0-3

Book design by Jean Peterson Design

Lyrics to "On the Way to Cape May" courtesy of
Lored Enterprises, Wildwood, NJ

Cape May for All Seasons
Preservation Media
P.O. Box 274
Buckeystown, Maryland 21717
1-888-522-0999

Printed in the United States of America

This book is dedicated to the

preservationists of Cape May, past, present, and future…

with thanks for safeguarding the treasures of

America's Only National Historic Landmark City.

ACKNOWLEDGEMENTS

First, let me thank

the wonderful people of Cape May. When I began the book with a survey of the Cape May Inns, I received kind and generous offers of lodging. Because I was expecting a baby after I began work on the book, I wasn't able to travel to Cape May as often as I would have liked, so I thank all of the Inns that I sadly missed out on visiting. I also wish to offer my most sincere appreciation to the following:

Dane and Joan Wells of the Queen Victoria B&B, for the earliest support I got from Cape May, and for their heavenly pillows...complete with a chocolate.

Sue McKenna of the Sea Mist, my first friend in Cape May.

Tom Carroll of the Mainstay Inn, for his support, his great book title, writing the foreword, and having the best hammock in America.

Bruce Minnix, former mayor of Cape May, and one of its true champions...for his guidance and wisdom.

The Virginia Hotel, whose room service actually brought me a chocolate milkshake at 11 p.m. during a winter visit when I was pregnant and really *needed* it.

Linda Loughlin of the Summer Cottage Inn, for the lyrics and her time.

Angel of the Sea hotel, for lodging and their delicious breakfast.

Harriet Wise, photographer extraordinaire.

Jean Peterson, for gracing this book with her graphic design talent and giving me the credit I hope I deserved.

Susan Williams, editor, supporter, and the best friend a Yankee could ever have.

You! For buying this book.

And most importantly thank you to my family, my husband (and business manager) Bob for his inspiration, and our beautiful daughters Sarah Grace and Molly Anne, two of Cape May's youngest enthusiasts.

PREFACE

Maybe it's the charming horse carriages, the welcoming porch rockers, or the delightful abundance of gingerbread on grand Victorian homes. Or maybe it's the free fudge samples and quaint shops on Washington Street Mall, the history and grandeur of the old hotels, or the magic of Sunset Beach.

But whatever the reason, I felt compelled to create a book which would capture the *flavor* of Cape May, New Jersey… to tap into its essence. I wanted those of us who are not fortunate enough to live in Cape May year round to have something to take home to remind them of this little haven by the sea.

I am by no means an expert on Cape May. I grew up near Philadelphia, PA (the locals in Cape May call me a "shoobie"), but I was born in New Jersey. My grandmother was a Miss Margate in the Miss New Jersey pageant, and my mom is from the Garden State, but I had never even set foot in Cape May until just a few years ago, on my birthday, on assignment for a magazine.

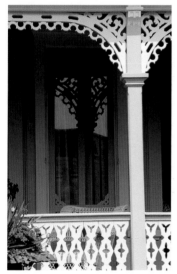

But I did fall in love. From the moment I arrived in Cape May, I knew it would be here I returned time after time to find peace of mind. Riding my bike (*the* way to travel in Cape May) through the streets and barely avoiding telephone pole collisions while gawking at Victorian landmarks, I knew it would be here I brought my children (and hopefully their children) for a lifetime of summers. Maybe even springs, autumns, and winters, for I was lucky enough to experience these seasons for the first time while working on this book - hence the title *Cape May for All Seasons*. If you haven't been here during the "shoulder seasons", make sure you visit. The parking's a lot better, there are a ton of shells on the beach, and it's pleasantly quiet. The town's holiday tree lighting ceremony complete with Santa himself, old-fashioned carolers, and warm cider rivals even the perfect Cape May beach day.

This is no history book. If you want to read about the fascinating past of Cape May, there are several wonderful books available. You won't be bored…this is a place which has withstood fire, flood, and the worst enemy, development. Maybe that's what I love best about Cape May… its ability to thrive in spite of adversity.

In that magazine article I wrote about Cape May a few years back, I called Cape May the "Hometown of my Heart". That it is. That it definitely is.

FOREWORD

By Tom Carroll
Owner/Innkeeper, The Mainstay Inn

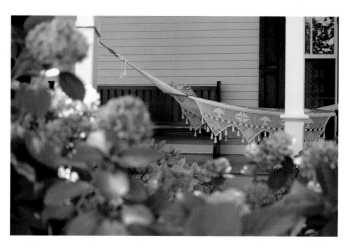

I have often thought that Cape May's seasonal visitors have a lot in common with our migratory wildlife. Birds and folks have found their own reasons to descend on our community at various times of the year, but both need rest and nourishment. Ruddy Turnstones need horseshoe crab eggs to refuel for the long flights between Antarctica and the Arctic while New Yorkers need seafood and California wines in a quiet setting before returning to life in the fast lane.

Our summer sun worshipers cannot imagine Cape May in a winter coat. Life for them is a great beach book, body surfing, and maybe a little skee ball during an aimless night stroll. Spring and fall guests commend themselves for avoiding the crowds and traffic; strolls along a quiet beach, poking through shops, and spending endless hours selecting a restaurant fills their day. Christmas visitors love the lights on Victorian gingerbread and the boarded up entrances to the arcades. Each season has its unique attractions and, therefore, its unique audiences.

Cape May for All Seasons records in words and photographs the many reasons both visitors and residents love this community. Mary has captured our spirit in a smooth-flowing narrative, while Harriet has discovered our very essence through the camera's lens. Together they have provided us the means to renew our love for Cape May from any location and at any time of year.

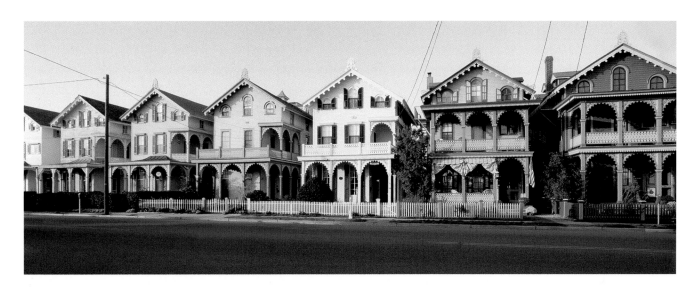

"America's Only National Historic Landmark City". "Queen of the Seaside Resorts". "Cool Cape May". "America's Oldest Seaside Resort". Whichever title you like best to describe Cape May, New Jersey, it is certainly the favorite vacation spot for many, home to lucky residents, and important stopping point for birds and birders.

One thing some people may not realize is that the Cape May historic district is entering the new millenium with the dubious distinction of a recent listing on Preservation New Jersey's "10 Most Endangered List". This listing came as a shock to many Cape May enthusiasts, and as an inevitable fate to others. Why the listing? Hasn't Cape May already escaped danger enough times? The fires, the floods, the development pressure… wasn't that all in the past? Apparently not, as Preservation New Jersey's "Most Endangered" listing states,

"Cape May city is at a crossroads, arguably a victim of its own success… The U.S. Department of the Interior is currently reassessing the city's

landmark status. What happens to Congress Hall hotel, the sole surviving grand hotel, which is currently empty of any guests and awaiting restoration, could be pivotal." (Preservation Perspective, Spring 1998)

In the listing, the 1996 demolition of the Christian Admiral Hotel is cited. This in itself is controversial. Was the Christian Admiral torn down because of overwhelming development pressure, as some preservationists claim, or was it literally rotting off the foundation and impossible to save, as others insist? Either way, the Christian Admiral can inarguably be called Cape May's Titanic, as its unmatched beauty and architectural opulence were not enough to save it from its tragic fate.

The choice of the quotes in this book which accompany the exquisite photography was no accident. As a writer, I had to choose whether to ramble on about how wonderful Cape May is… or to let you see for yourself. I chose to let the photographs speak for themselves.

Seeing no need to reinvent the wheel, I selected historic Cape May quotes that inspire some reflection about Cape May, about the importance of its preservation. Of course, there's always room for whimsy, and many will recognize the lyrics to "On the Way to Cape May" as quintessential Cape Mayana.

I knew that Tom Carroll, the "Unofficial Mayor of Cape May", would offer the perfect welcome to this book, and I also knew that Bruce Minnix, former mayor and not-so-local celebrity, would be able to best speak about Cape May's preservation past, present, and future. We are fortunate to have these pages graced with their thoughts, for they are two of Cape May's champions, among others whose names you will find in the quotes, and among still others who work behind the scenes to protect their seaside sanctuary.

America's Oldest Seaside

Resort

T H E S E A

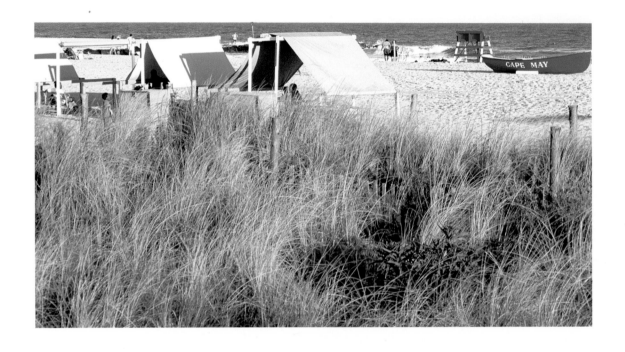

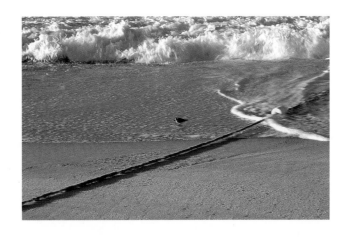

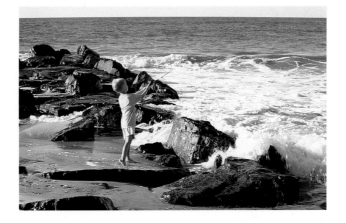

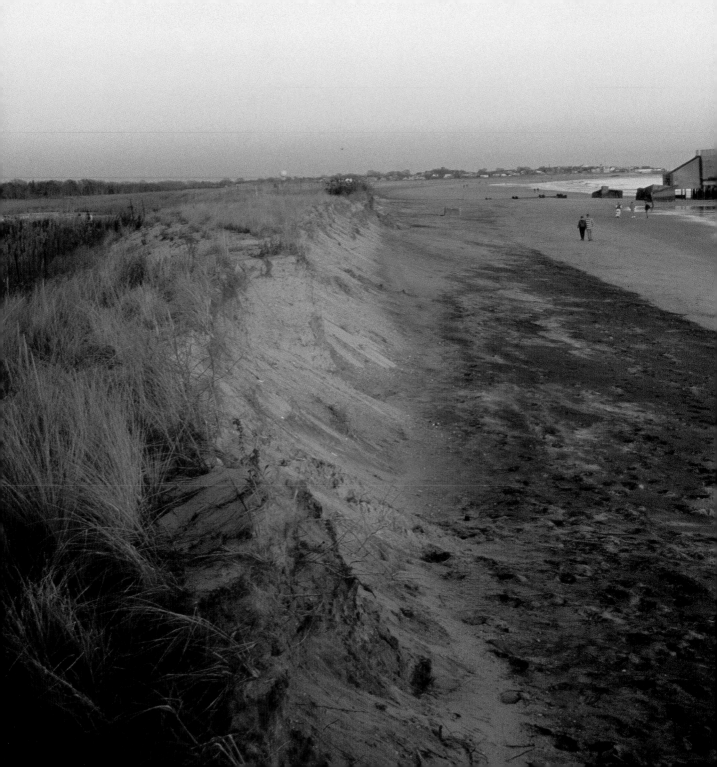

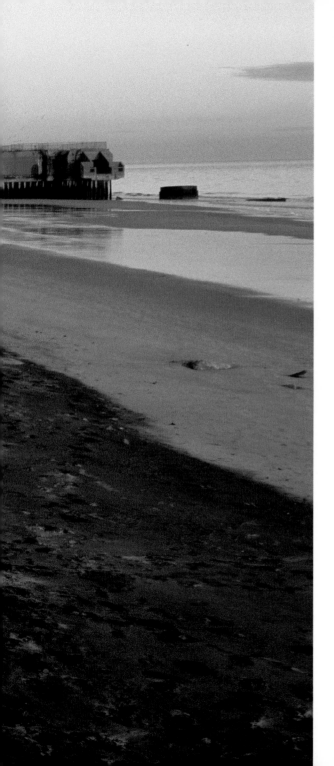

"If you have been to Cape May before, your return is no accident. If this is your first visit, you should be advised that Cape May will become habit-forming. But such an addiction is in no way hazardous to your health."

Jean Trotten Timmons and Donald Parsons Timmons, *This is Cape May: America's Oldest Seaside Resort* (Third Edition), 1979.

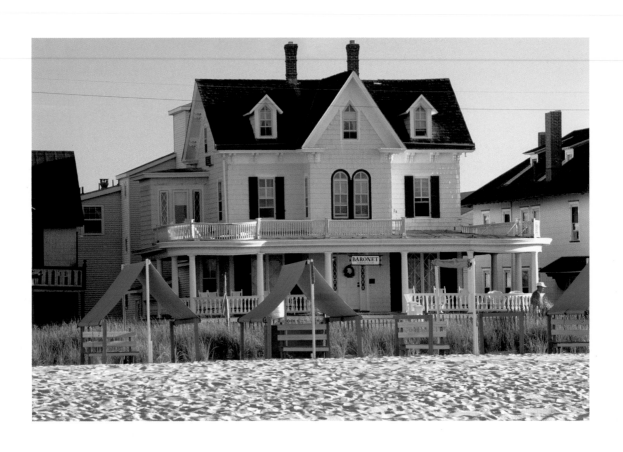

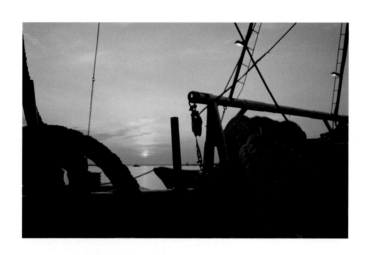

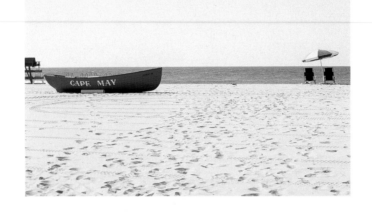

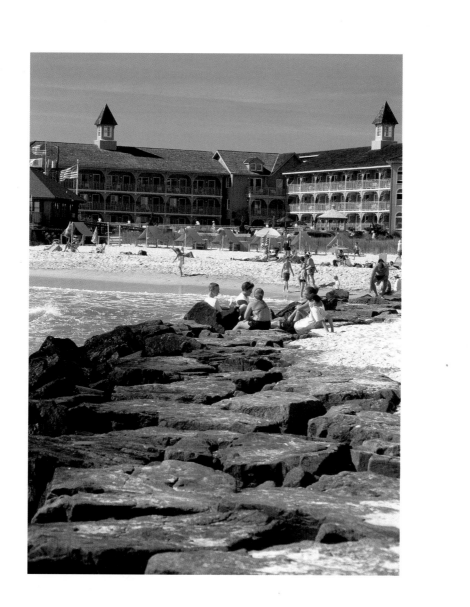

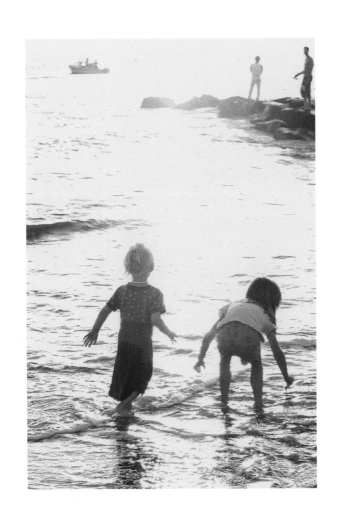

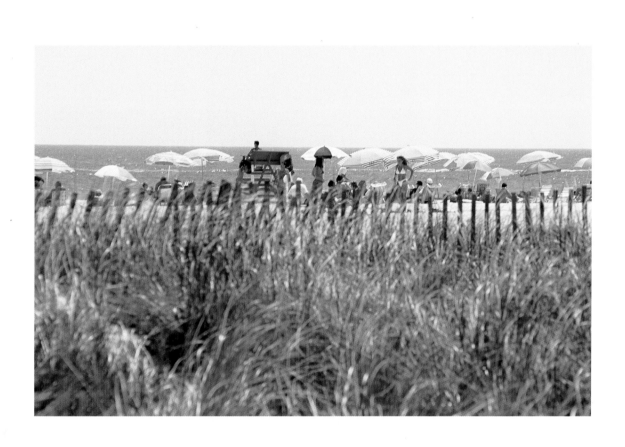

"Queen

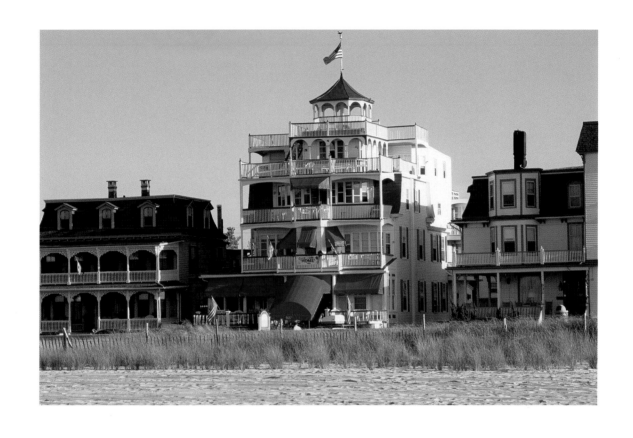

of the Seaside Resorts"

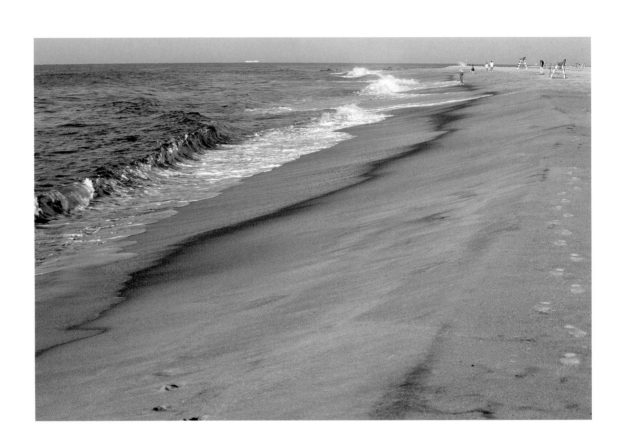

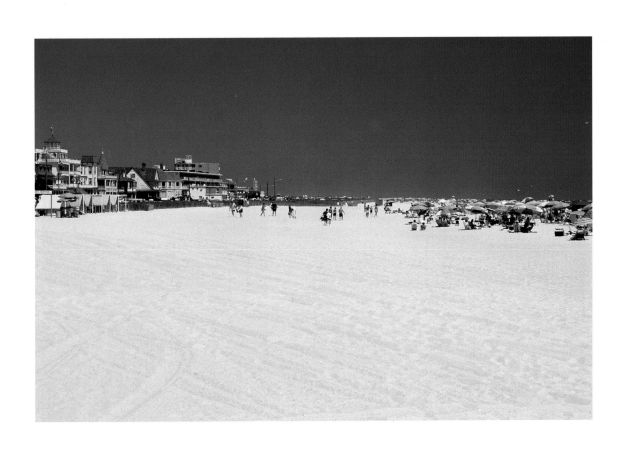

 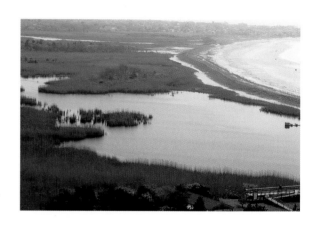

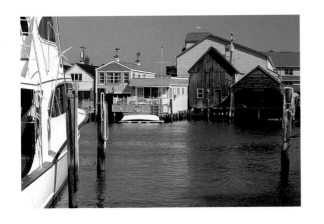
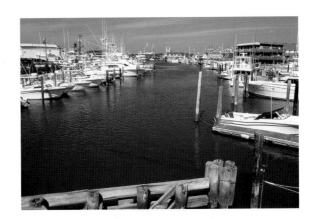

"(I find the) climate charming and the land fruitful."

Dutch Sea Captain Cornelius Jacobsen Mey, 1609

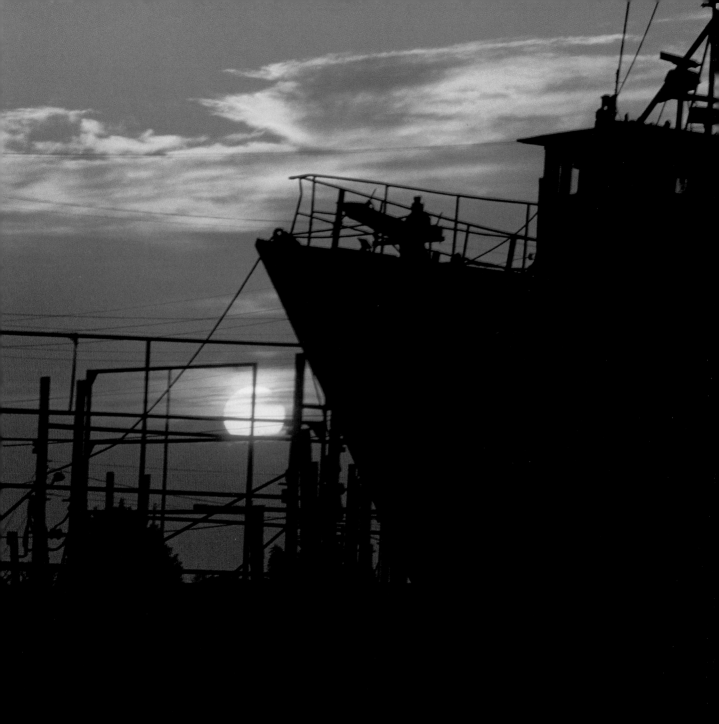

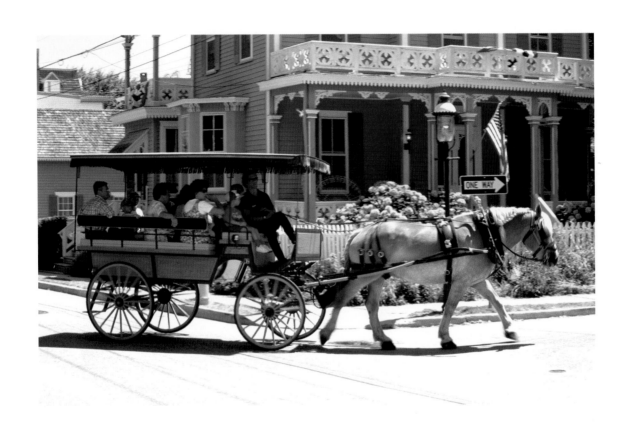

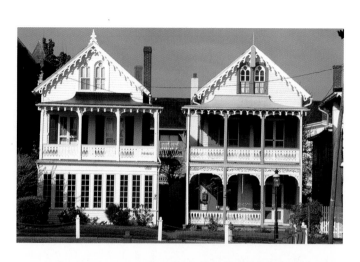

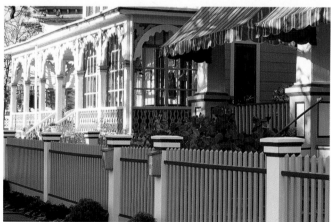

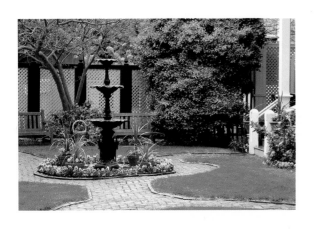 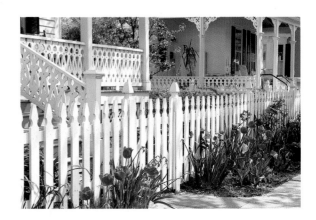

"America's Only National

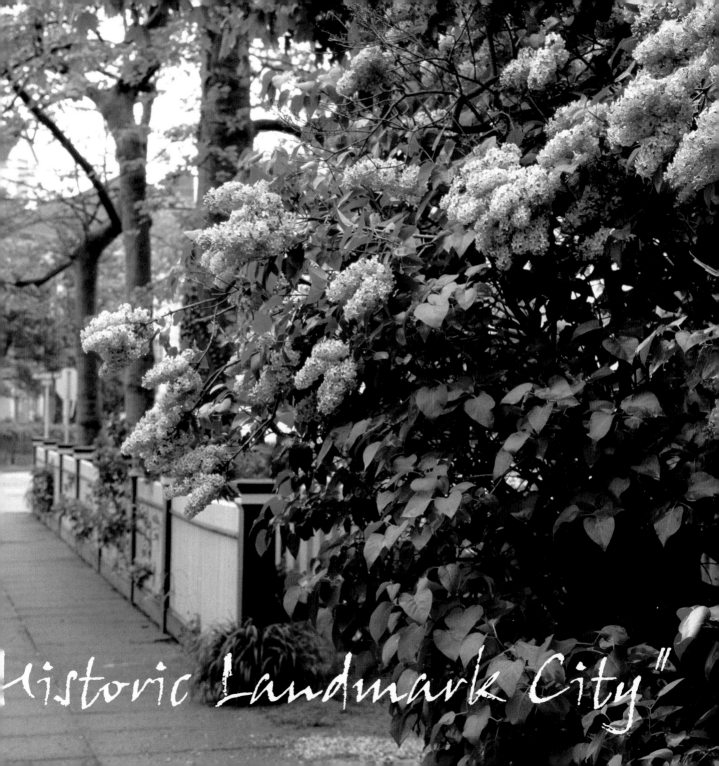

Historic Landmark City"

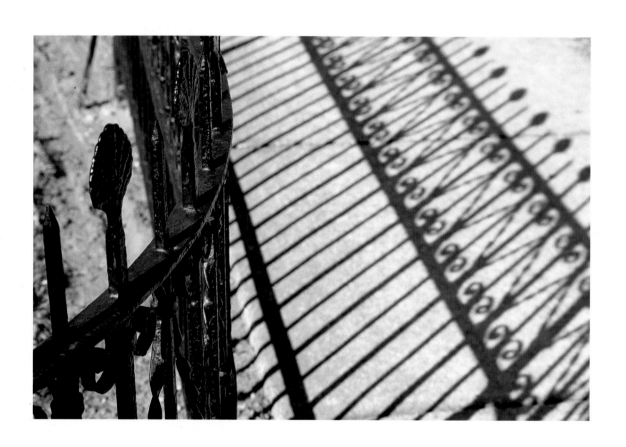

"A strange transformation takes place as one enters a town that might have been brushed in by a 19th century artist— the car becomes a hindrance— a trapping of the 20th century that somehow feels out of place. This is a town to get close to and the best way to absorb its presence is to walk."

Marsha Cudworth and Howard Michaels
Victorian Holidays: An Illustrated Guide to Favourite Guest Houses, Bed and Breakfast Inns and Restaurants of Cape May, New Jersey, 1982

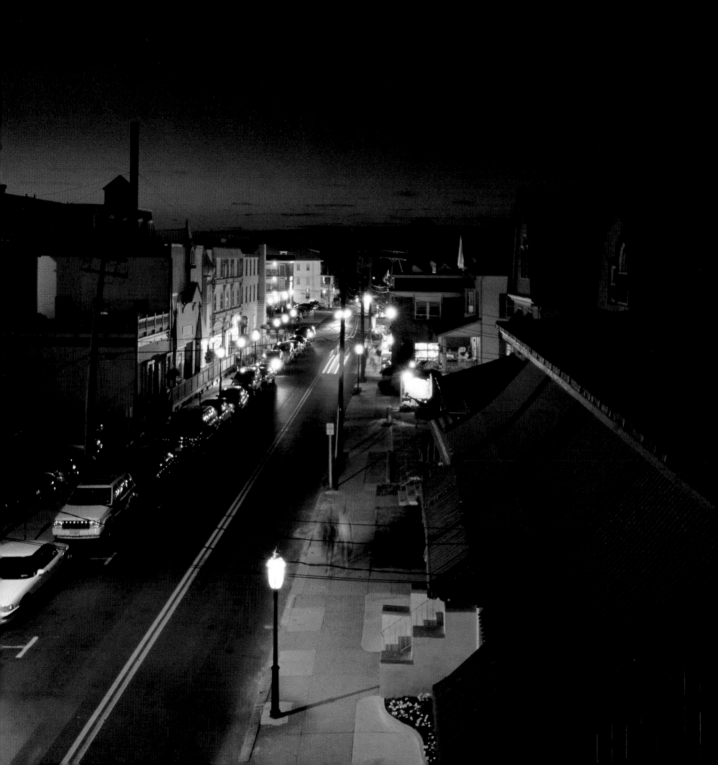

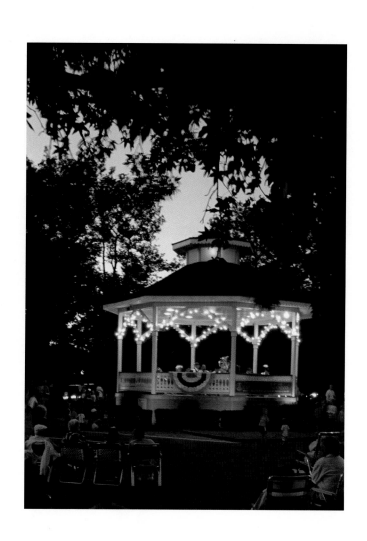

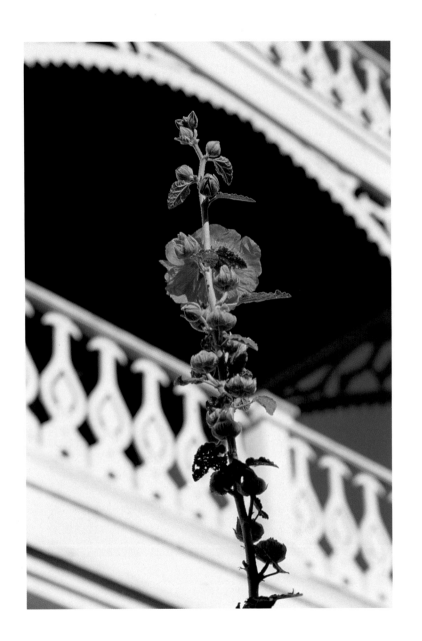

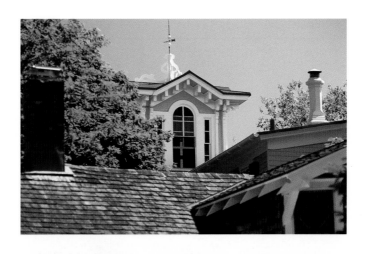

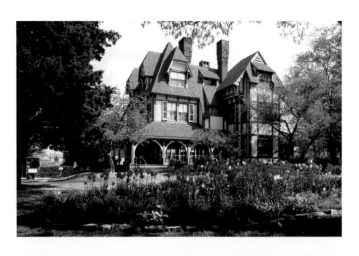

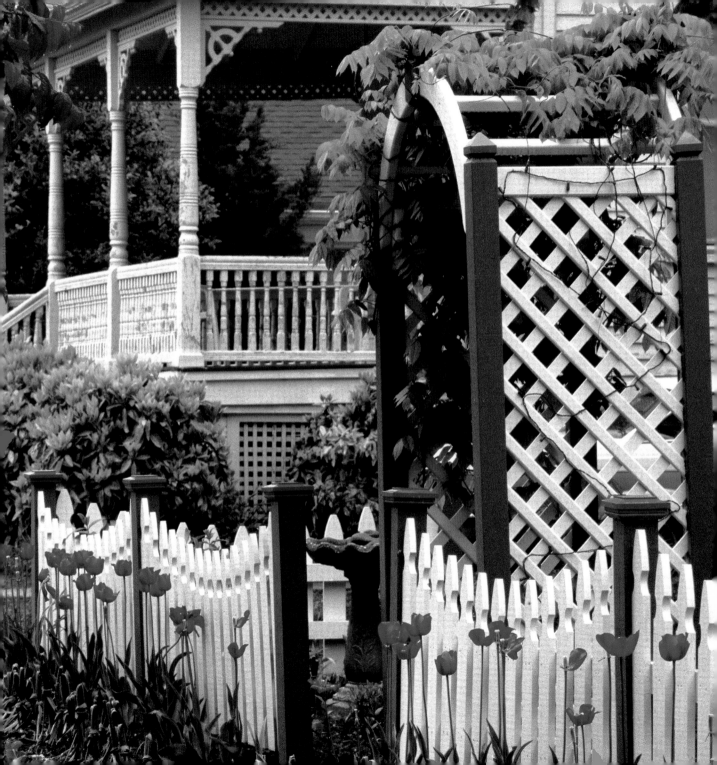

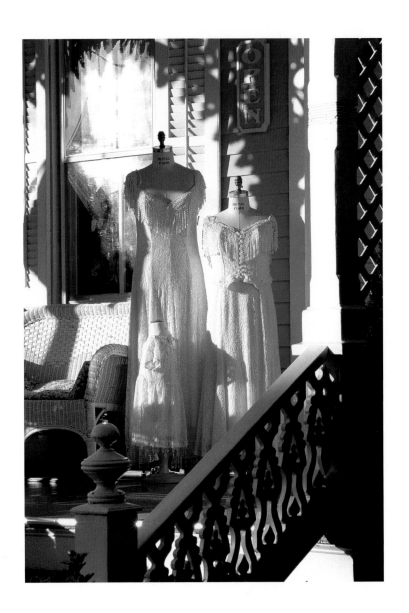

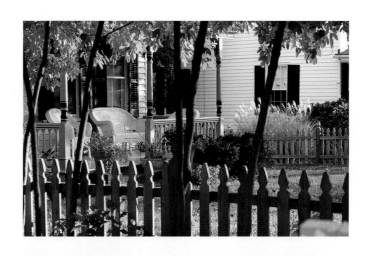

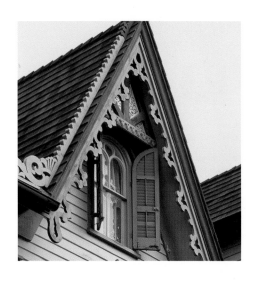

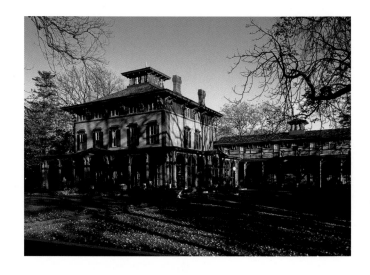

"...the citizens of Cape May, the
collections of late 19th century frame

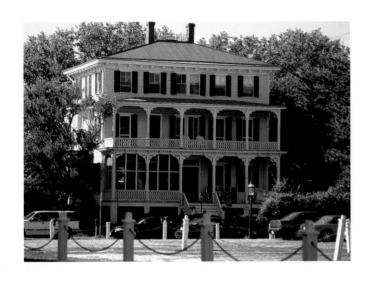 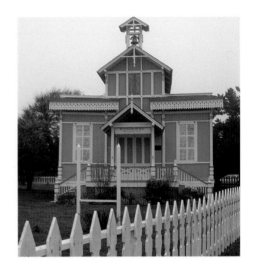

custodians of one of the largest buildings left in the United States."

Carolyn Pitts, Michael Fish, Hugh J. McCauley AIA, Trina Vaux *The Cape May Handbook*, 1977

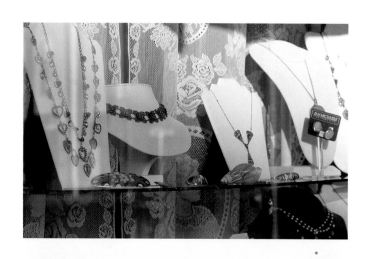

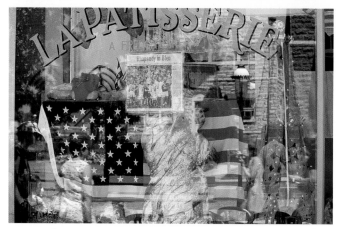

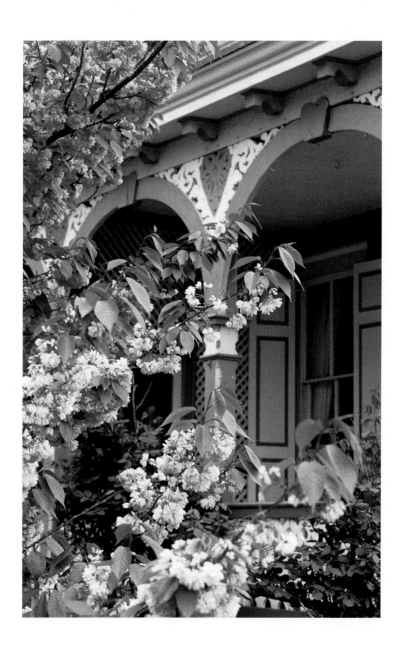

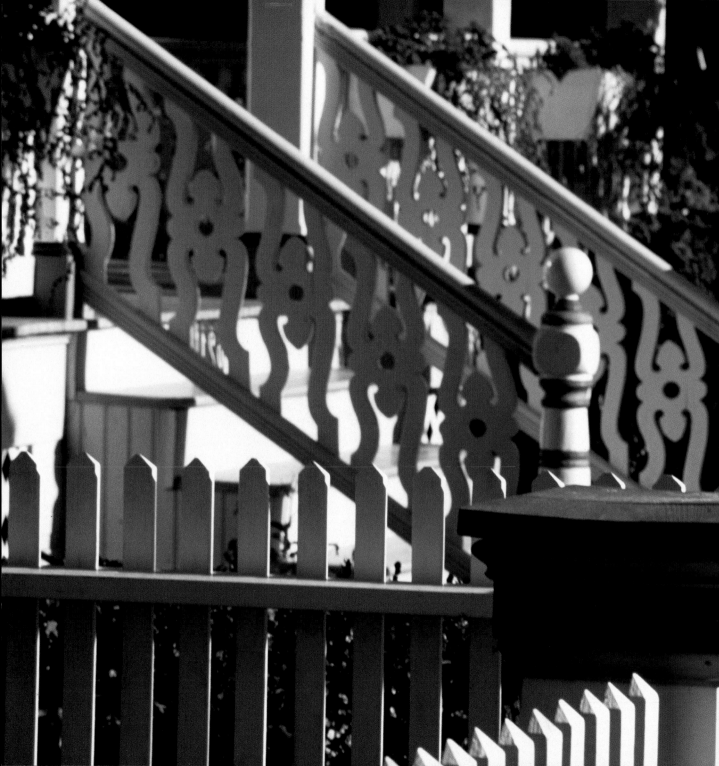

"It continues to amaze me how passionate the people of Cape May, and its neighboring towns, are about their community. This is the kind of town where during the quieter months people stop their cars in the middle of the street and chat for 10 minutes, leaning companionably out of driver's side windows. This is the kind of town where a trip to the grocery store can turn into a two-hour expedition bumping into people you know. I've had a taste of this and I find it immensely refreshing."

Ernesto A. Burden, Burden on Society column, *Cape May Star & Wave*, October 1997.

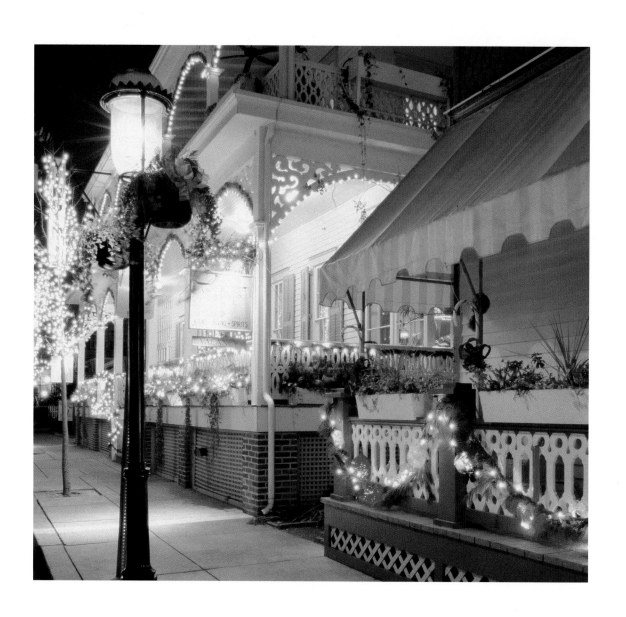

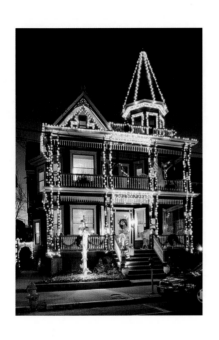

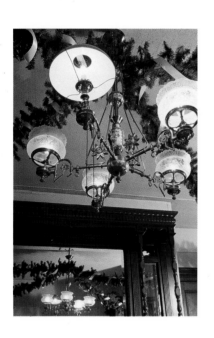
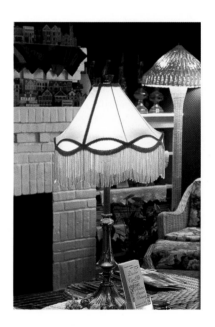

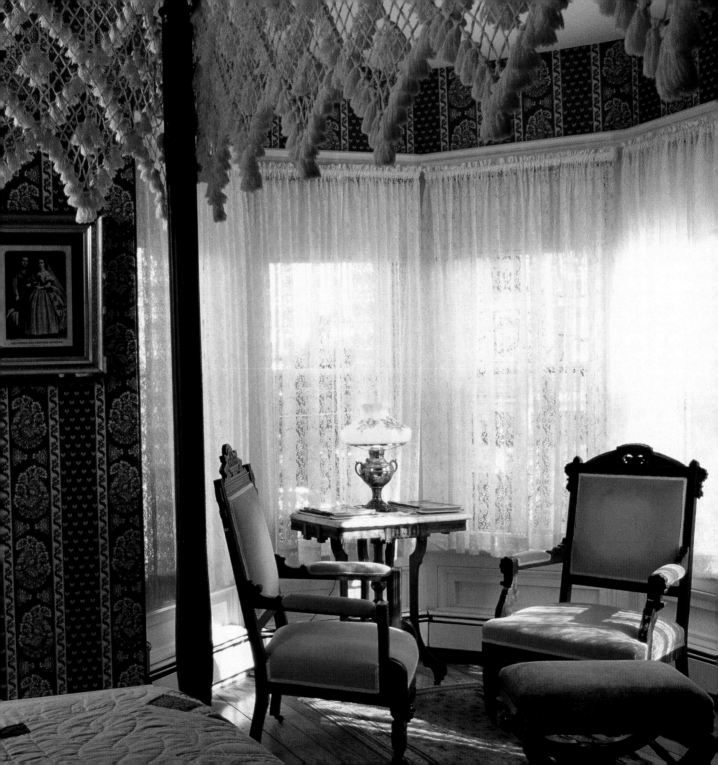

"It is little old seaside survives. Victorian century of changes in increasing

short of miraculous that the resort of Cape May, New Jersey, But somehow its small wooden buildings have weathered a storms, braved fires, outlasted taste, & even now remain despite commercial pressures. "

George E. Thomas, from George E. Thomas and Carl Doebley, *Cape May: Queen of the Seaside Resorts*. 1976.

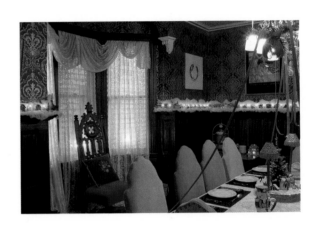

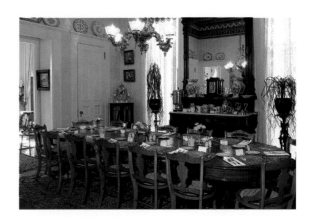

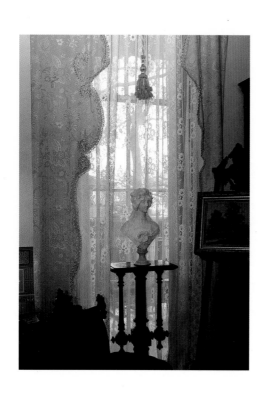

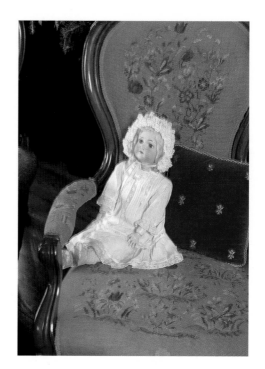

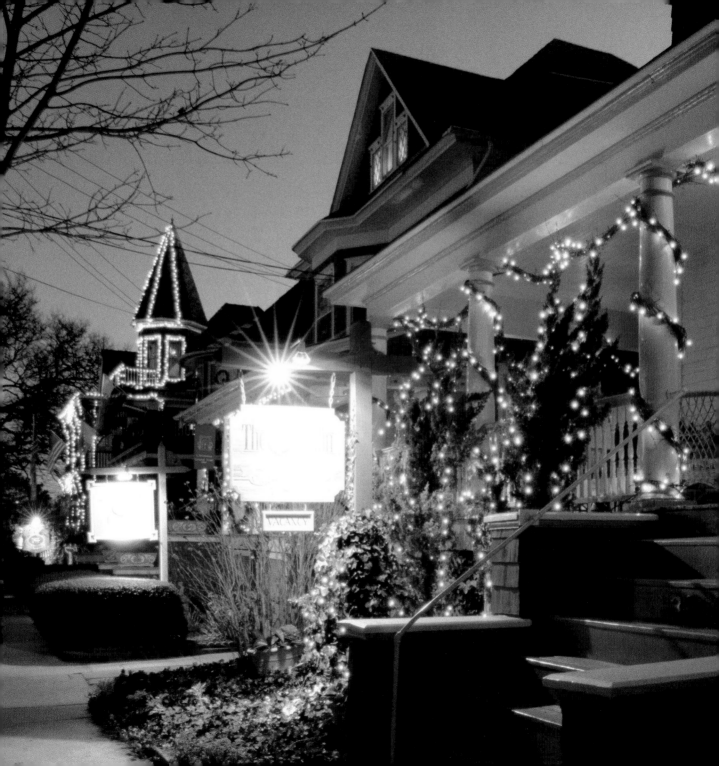

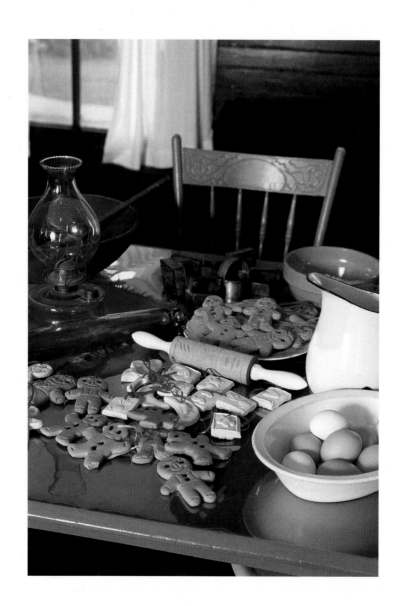

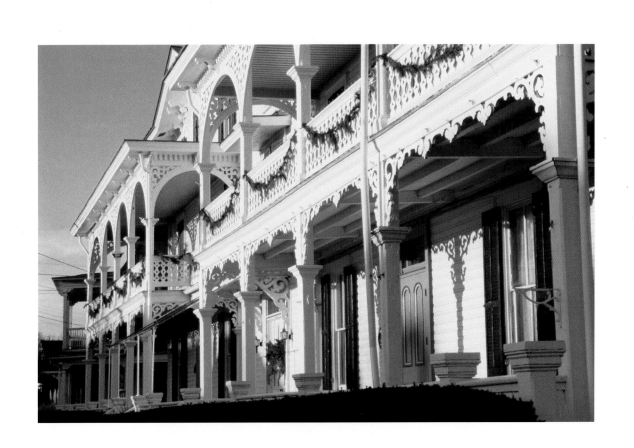

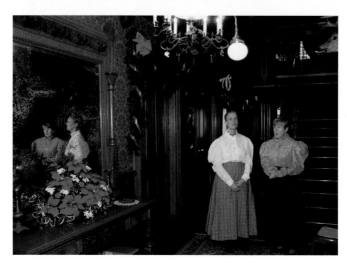

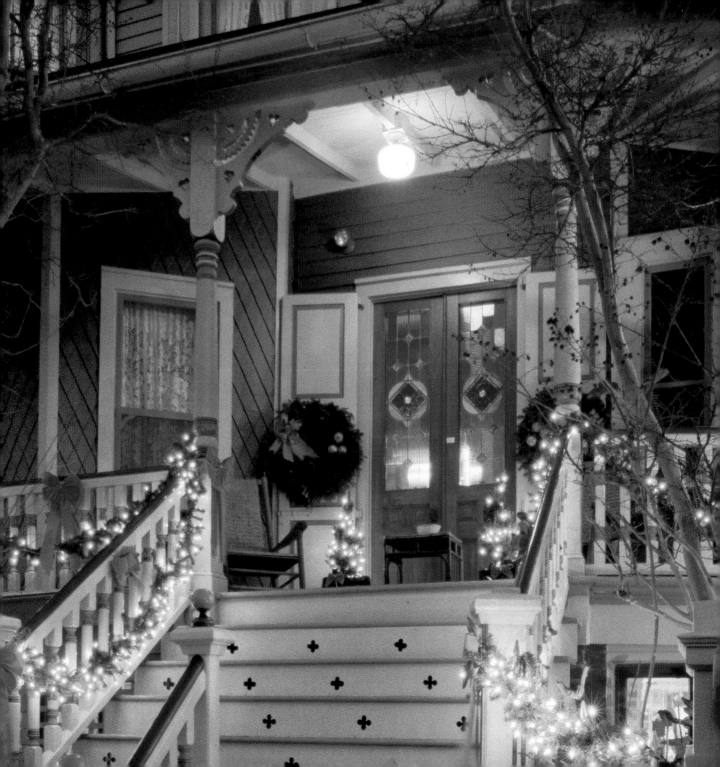

"Preservation of unique buildings in a setting that respects them enhances their economic usefulness and aesthetic attractiveness. It enriches the City and County of Cape May, the state of New Jersey, and the nation."

Carolyn Pitts, Michael Fish, Hugh J. McCauley AIA, Trina Vaux *The Cape May Handbook*, 1977

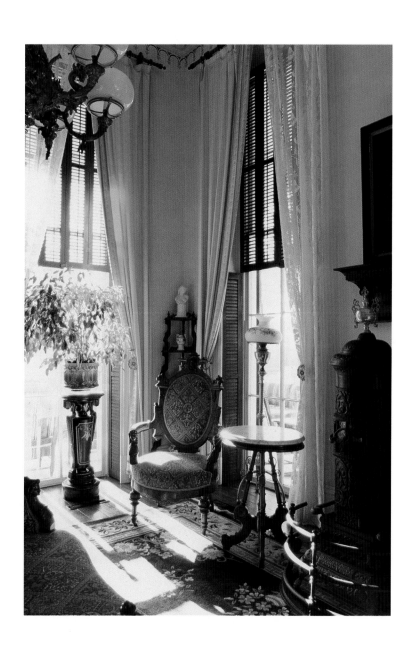

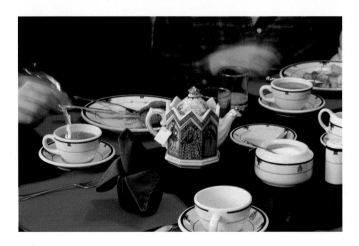

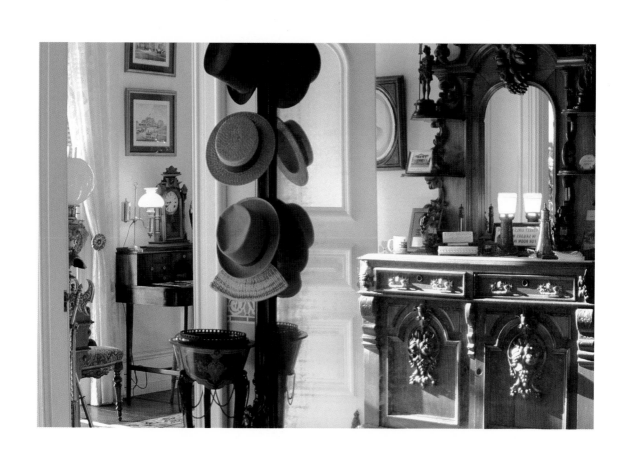

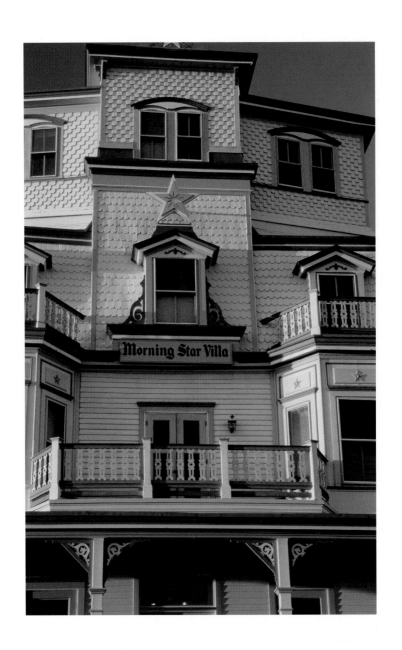

"Cool Cape May:
20 Miles at Sea"

Advertising slogan coined in 1896
on promotional Cape May materials

"Despite the optimism that Cape May's redevelopment encourages, there are a number of serious problems that must be solved if the old resort is to survive in its present form into the twenty-first century. Most important, Cape May must be perceived as a visual and physical environment made up of small cottages, most of which are not individually important, but which form parts of streetscapes that are the very essence of the town. Each demolition or careless restoration diminishes the town and makes it less viable. The traditional attitudes toward property and the rights of the individual must be weighed and balanced with the needs of the entire community."

George E. Thomas, from George E. Thomas and Carl Doebley, *Cape May: Queen of the Seaside Resorts*. 1976.

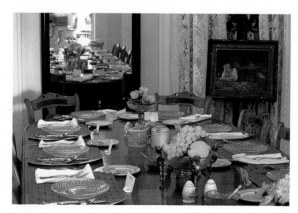

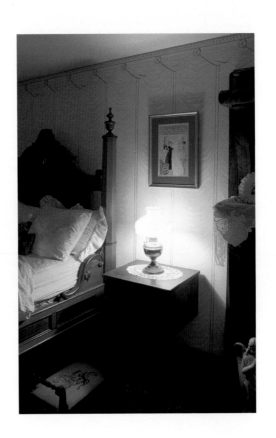

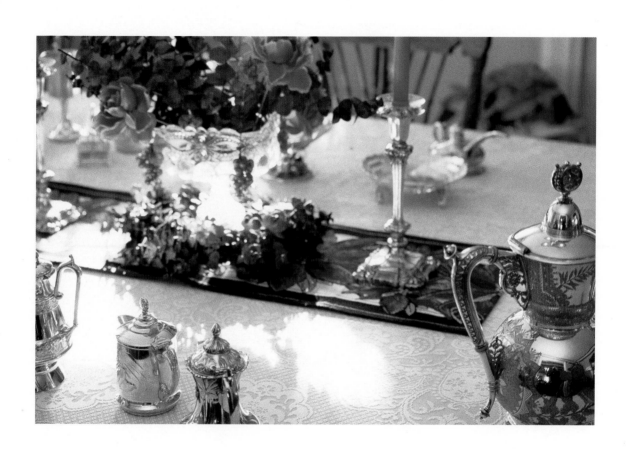

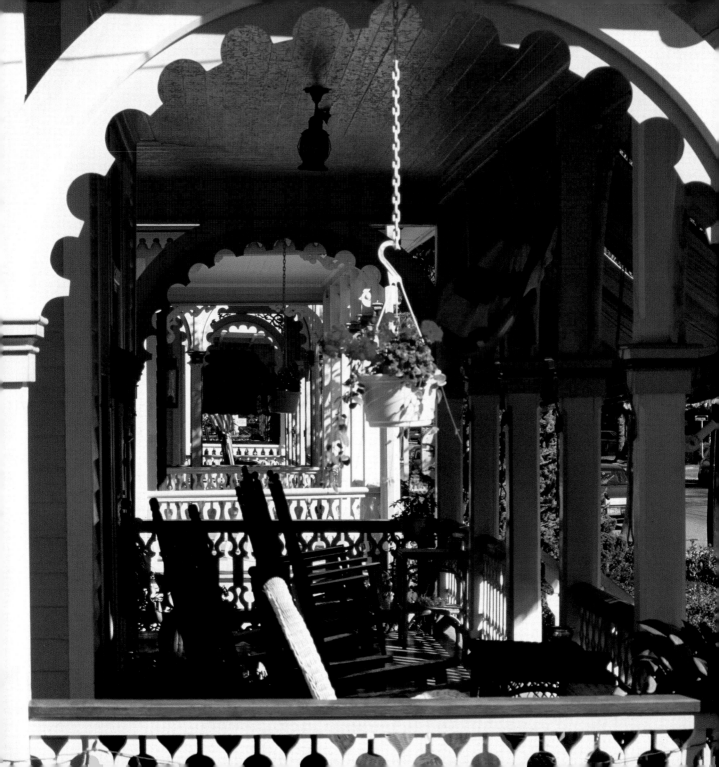

T H E P O R C H E S

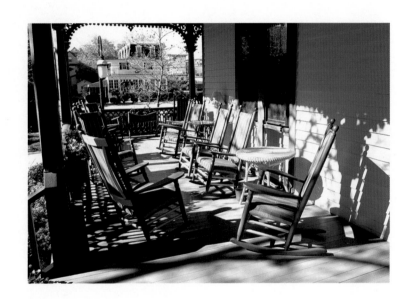

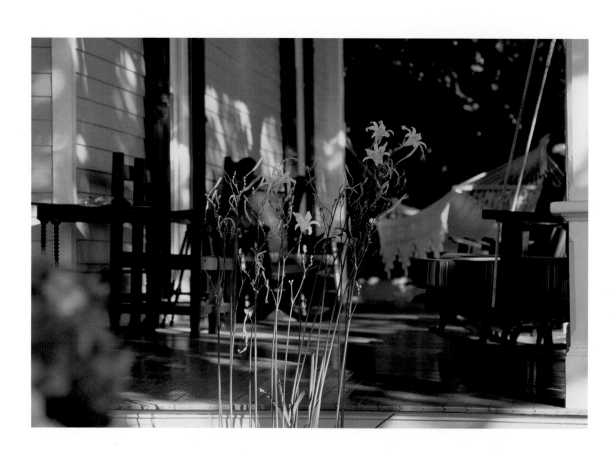

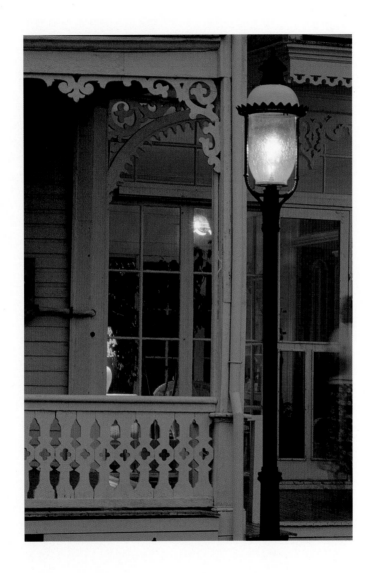

"In an effort to create a picturesque milieu, there is the danger of inadvertent confusion, for it becomes increasingly difficult to differentiate the real from the imitation. That can only serve to confuse the issue and to demean the reality of what Cape May is— not a Victorian Disneyland, but the survival of a real Victorian resort."

George E. Thomas, from George E. Thomas and Carl Doebley, *Cape May: Queen of the Seaside Resorts*. 1976.

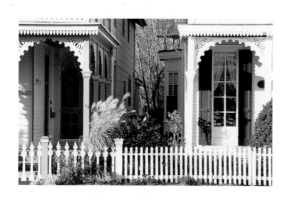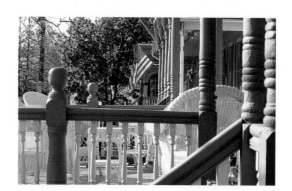

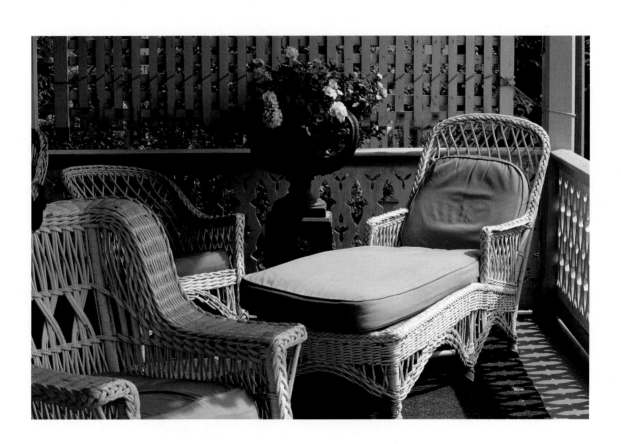

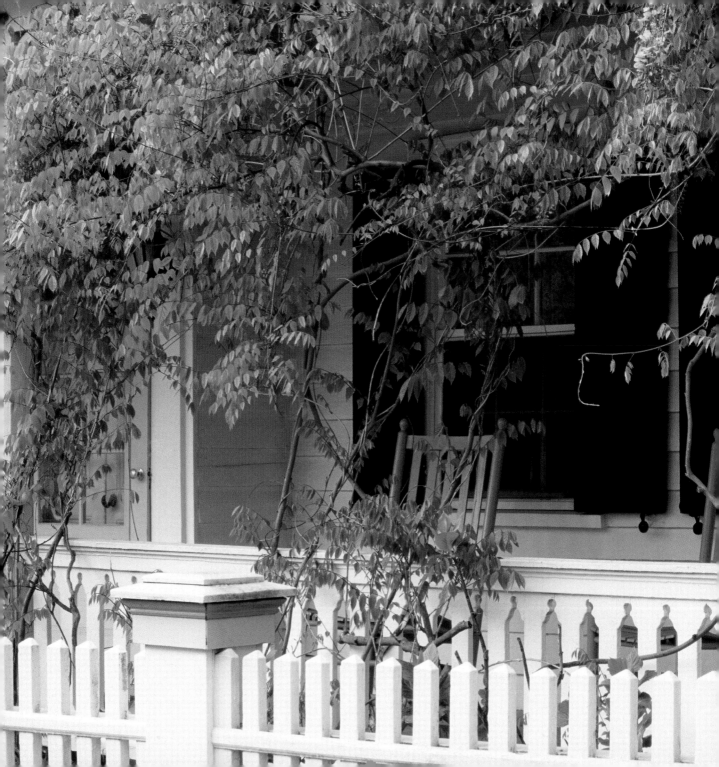

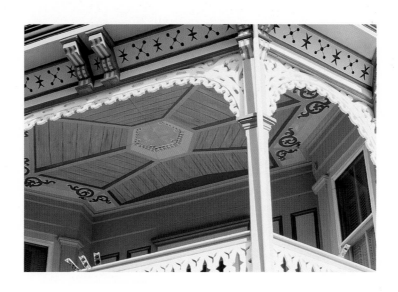

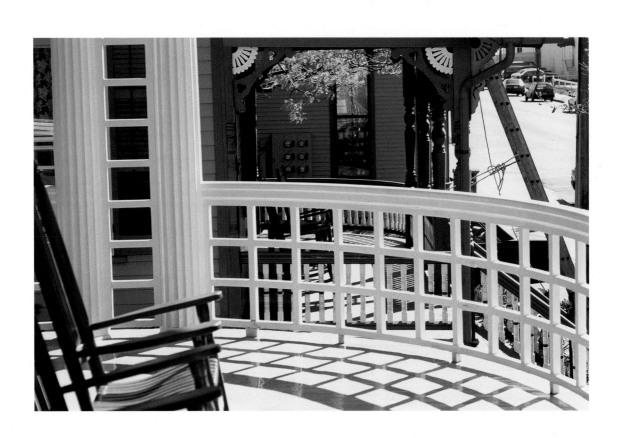

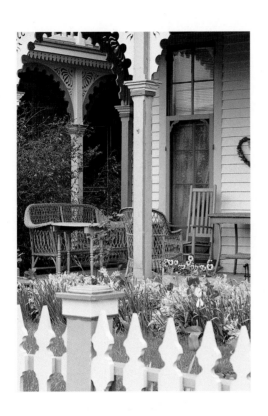

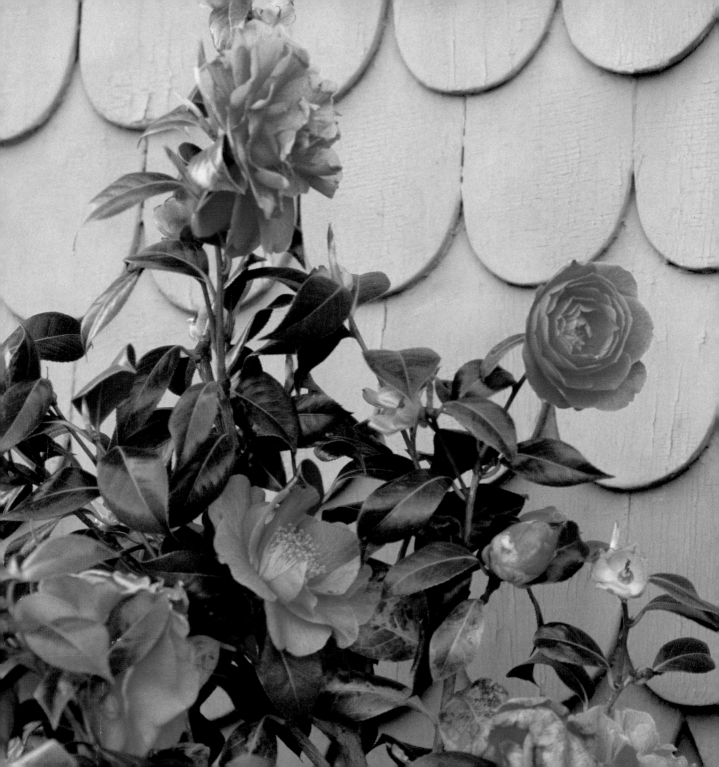

On the Way to Cape May

You looked so very pretty, when we met in Ocean City,

like someone, oh, so easy to adore.

I sang this little ditty, on our way to Ocean City,

heading south along New Jersey's shore

On the way to Cape May, I fell in love with you

On the Way to Cape May, I saw my dreams come true

I was taken by your smile, as we drifted by Sea Isle

My heart really was gone, when we reached Avalon

On the way to Cape May, Stone Harbor's skies were blue

We were naming the day, when Wildwood came in view

If you're gonna be my spouse, we'd better heard for that courthouse

On the Way to Cape May

On the Way to Cape May

By Bruce Minnix
former Cape May mayor, owner of Holly House, and award-winning television producer/director

When my wife and I discovered Cape May in the early 1950s, we knew we had found a treasure- a quiet town with a wonderful beach and a very special appeal. We bought a house and never regretted it. We were living in a town from another time.

But it began to change. Houses from the nineteenth century were torn down to make way for modern motels. Lawns and gardens were replaced with black top parking lots. There seemed to be no value given to the past. The very thing we bought was being destroyed.

When something is wrong, action is needed. We got involved. We became preservationists and we weren't alone. Many others felt the same way. A true grassroots movement developed that won control of the City Council with me as mayor.

Preservation became the town watch word. The mindless destruction of the beautiful old houses was stopped. The building height for new construction was lowered, forcing new structures to be more compatible with neighboring buildings. Government grants saved the 8$^1/_2$ acre Physick Estate, and a cultural and community center was created there. A small triangle of land with lovely old trees was made a park instead of a sixteen car parking lot. New uses were allowed in historic buildings so that owners could afford to keep them and fix them up.

The community was enthusiastic. Beautiful restorations were done. The town itself became an attraction. Success bred success. Once more Cape May became the Jewel of the Jersey Shore.

My proudest achievement as mayor was having the entire town designated a National Historic Landmark. It was a triumph for the forces of preservation.

With success comes added pressure to change, to be bigger, and to be more so. Such pressure can ruin the very thing that was saved. Preservation should not mean decorate more. Preservation should not mean modernize. Preservation should save the past today for the future to enjoy tomorrow.

Cape May is a lovely town, charming and delightful. It is also in danger. Again. Now, with all its success, there is money and there is pressure to make everything more so. So much more so, that it can cease to be charming and delightful. It can become more and more a carnival. That will make Cape May less and less the quiet, graceful town so well loved by so many.

There is one certainty in the Preservation War.

The battle may be won, but the war is never over!

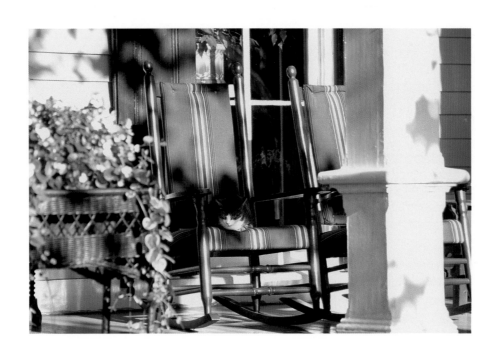

For information about the inns and bed-and-breakfasts of Cape May,

call the Cape May Chamber of Commerce at (609) 884-5508
or write to the Chamber at P.O. Box 556, Cape May, NJ 08054.
You can also visit www.beachcomber.com
for a wealth of information about Cape May.

For tourism and event information about Cape May,

call the Mid-Atlantic Center for the Arts at (609) 884-5404
or write MAC at P.O. Box 340, Cape May, NJ 08054
or visit their website at: www.capemaymac.org

ADDITIONAL INFORMATION

Historic Accommodations of Cape May,
P.O. Box 83, Cape May, NJ 08054
or call for room availability (609) 884-0080

On the Way to Cape May lyrics/music/cassette:
Write to Lored Enterprises at
P.O. Box 1287 (5600 Park Blvd.)
Wildwood, NJ 08260

For ordering information for the 1998 updated edition of
Cape May: Queen of the Seaside Resorts
by George E. Thomas, et.al.,
contact the Mid-Atlantic Center for the Arts at (609) 884-5404.

ORDERING INFORMATION

Preservation Media, P.O. Box 274, Buckeystown, Maryland 21717 • 1-888-522-0999
or if you are in Cape May you can find *Cape May for All Seasons* at the
Celebrate Cape May shop, 315 Ocean Street or visit their website at: www.celebratecapemay.com

A B O U T T H E A U T H O R

Mary T. McCarthy

Mary McCarthy works as a professional freelance writer and television producer specializing in historic preservation. She has written feature articles for the Baltimore *Sun*, Philadelphia *Inquirer*, and other publications. In addition to serving as a Marketing and Public Relations consultant to the Chamber of Commerce of Frederick County, she also serves on the Frederick County Historic Preservation Commission and is a board member of the Frederick County Landmarks Foundation.

Born in New Jersey, Ms. McCarthy grew up in King of Prussia, Pennsylvania. She is a graduate of Western Maryland College in Westminster, Maryland, and currently resides in Frederick, Maryland with her husband Bob and daughters Sarah Grace and Molly Anne.

A B O U T T H E P H O T O G R A P H E R

Harriet Wise

Harriet Wise is a freelance architectural and studio photographer in Frederick, Maryland for corporate, industrial, and editorial clients. They are as diverse as her interests. Her photographs are shown regularly in galleries and are included in several books.

She received a BA in Art and pursued graduate studies in photography at The Maryland Institute College of Art, the Corcoran School of Art and The Maine Photographic Workshops. Formerly an art and photography teacher for the public school system and community college, she also lectured at Johns Hopkins University School for Continuing Studies.

Harriet photographs nationally for the Historic American Building Survey, has received many ADDY awards in advertising, and published her work in *Country Inns, The Washington Post, Mid-Atlantic Country, Architecture, The New York Times, Washingtonian,* and other publications. She produces an annual calendar featuring architectural themes.

Harriet wishes to thank the busy innkeepers of Cape May for their efforts to keep the city picturesque, charming, and friendly. Specific thanks are extended to Dane & Joan Wells, Rita & John Tice, Tom Carroll, Pat & Tony Marino and the staff at MAC for their suggestions, insights and lively stories.